VICTORIA AND ALBERT MUSEUM

BEWICK

WOOD ENGRAVINGS

Frances Hicklin

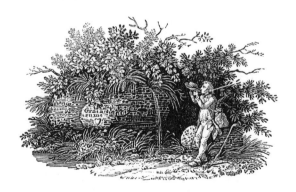

London
Her Majesty's Stationery Office

© *Crown copyright 1978*
First published 1978

ISBN 0 11 290290 1

Note. The illustrations in this booklet have been reproduced
from four albums of proofs of Bewick's wood-engravings in
the Museum's Department of Prints & Drawings. Refer-
ences in the captions are to the numbers in the albums.
Copies of books illustrated by Bewick may be consulted
in the Museum Library.

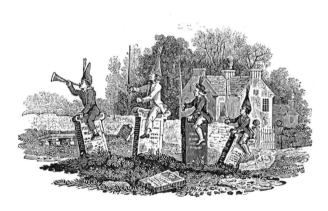

2 'Cavalry in the churchyard'. *Vignettes* (No. 48). E. 2304–1907

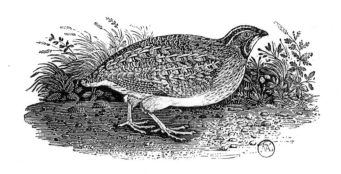

3 Quail. *British Land Birds* (No. 148). E.1898–1907

THOMAS BEWICK was born in 1753 at Eltringham, a village eleven miles west of Newcastle and just south of Hadrian's Wall. Throughout his life he remained rooted in his native Tyneside. Apart from the occasional trip to Scotland or York, and less than a year in London as a young engraver in the printing trade, he never seems to have felt the need for a change, Newcastle and its surroundings being to him what the Suffolk landscape was to Constable.

Most of what we know about Bewick comes from his *Memoir* written in the last four years of his life at the request of his daughter Jane. The eldest of eight children born to a farmer and colliery owner, Thomas was entrusted to the care of his Aunt Hannah, who by his own account must have found him a handful. 'From early in the morning till late at night I was scarcely ever out of action', he says. And many were the resulting tumbles and scalds.

His first schoolmaster was an ignorant bully whose sense-less beatings turned Thomas into a regular truant. Stark naked he would be joined by his friends as they dashed about the fells in imitation of the 'savages' they imagined from *Robinson Crusoe*. Angling, swimming in burns, tree-climbing, or riding bareback on his father's uncontrollable horse were other favourite occupations. He was an intrepid boy with an iron constitution.

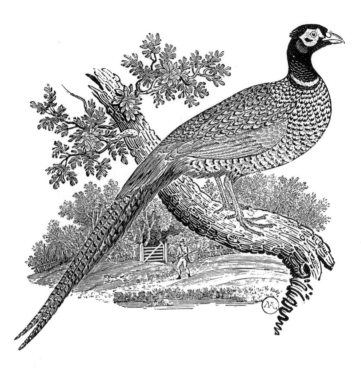

4 Pheasant. *British Land Birds* (No. 138). E.1888–1907

Besides school, church was another place of tribulation, floggings often being supplemented by solitary confinement there until nightfall. When fears of 'ghosts and boggles' threatened to overcome him, the resourceful boy would keep his spirits going by shinning up the pillars with the help of his handkerchief. Boredom at Matins was got over rather differently—he would draw figures on the soft painted book board with a pin. 'In doing this,' he says, 'no one noticed me as I held down my head and, having got the church service off by heart, I repeated it the same as the congregation.'

That pranks and larks were meat and drink to him is apparent from the light-hearted tail-pieces which figure in

his work. Examples abound: a frantic mother dashes to save a tot unconcernedly tugging at the tail of an eye-rolling carthorse (*Danger*, Front outer cover); an irreverent crew in comic hats straddle a row of tombstones (*Cavalry in the Churchyard*, pl. 2); a traveller uses his hatbrim to drink from a wayside spring (pl. 1, Title-page), while a reveller rolls home seeing two moons in the sky.

Not all his youthful sport was kindly, however. Dogs were teased, beasts frightened, and half-wits mocked. In a rugged age Tom had to learn to give as well as take black eyes. Yet, as he matured, the boy developed an unusual sensibility. He described with feeling how at a hunt he once held a fear-crazed hare in his arms in an attempt to save her, and how distressed he felt on another occasion at having killed a small bullfinch. Cock-fights and boxing matches, the common entertainments of the day, which he would have witnessed going about with his father, also ended by disgusting him. He notes the wry faces and agitated contortions of the bystanders.

Yet he shows consistent affection for his fellow Northerners—the stalwart miners in his father's colliery, the local preachers and teachers, even the poachers, these are the people with whom he feels at home.

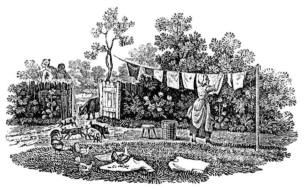

5 Washing on the line. *Vignettes* (No. 160). E.2360–1907

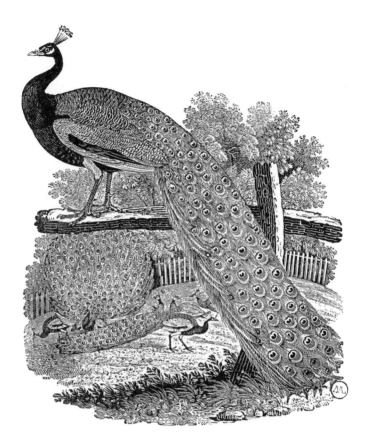

6 Peacock. *British Land Birds* (No. 140). E.1890–1907

Speaking of the long journeys he made with his father to collect the money due to him for coal, Bewick writes of the kindness and hospitality of the people, of countenances, high and low, beaming with cheerfulness 'heightened everywhere by the music of old tunes from the well-known, exhilarating, wild notes of the Northumberland pipes', the buzz of the Morris Dancers and the effects of home-brewed ale.

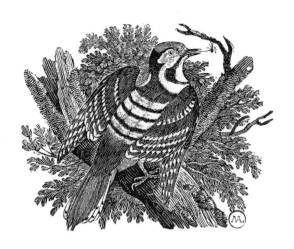

7 Barred Woodpecker. *British Land Birds* (No. 63). E.1813–1907

Although Mr Bewick senior enjoyed taking his sturdy son about, he had no time for the boy's urge to draw, holding it 'an idle pursuit'. Without proper materials Tom would fill up the margins of his schoolbooks, chalk his designs on gravestones and even on the floor of the church porch. Seeing the child's scorched face after a pavement session on the family hearthstone a kind friend furnished him with paper. 'Pen and ink and the juice of the brambleberry made a grand change.' Soon he moved on to colour and was ornamenting the walls of his rustic neighbours 'with an abundance of my rude creations (drawn from the woods and wilds of my native hamlet) *at a very cheap rate*'. The great demand was for hunting scenes and horse portraits. But for young Tom creatures small as well as great were of riveting interest. Perhaps it was not an accident in an age which was to produce Linnaeus and Gilbert White of Selborne to find a schoolboy observing the behaviour of ants in a manner that would not be out of place in J. H. Fabre's *Social Life in the Insect World*.

On 15 October 1767, at fourteen years of age, the 'stout

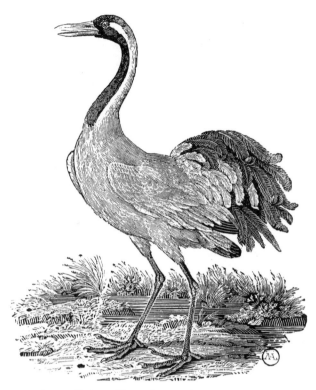

8 Crane. *British Water Birds* (No. 12). E.1919–1907

boy' was, for £20 apprenticeship fee left him by his grand-
mother, bound for seven years to one of the Beilby brothers,
engravers of Newcastle. The business was a mixture of seal
cutting, painting, and enamelling. After a suitable period
spent in copying Copeland's *Ornaments*, Thomas was
promoted to cutting blocks for advertisements. He never
had a drawing lesson but his experience with Beilby was
full of variety. Such was the industry of Tom's master that
he would take on anything from a brass clockface to a bank-
note. Between the distasteful business of polishing metal
plates Thomas would now and again be allowed 'a nice

job' such as cutting the mottoes on the insides of rings. But it was not until Newcastle printers began asking for wood blocks for bar bills and children's books that young Bewick came into his own. At the end of his 'time' the Society for the Encouragement of Arts awarded him a prize for his *Select Fables* cuts; a sum which the dutiful son proudly presented to his mother.

These were intellectually as well as vocationally formative years. A local bookbinder, Gilbert Gray, allowed him the run of books coming in for binding. Beilby's library provided Smollett's *History of England*. Too much poring over religious works and the too low position of his work bench proved debilitating, however, and the local doctor was called in to prescribe air, exercise, and a proper diet (at one stage Bewick seems to have been living largely on milk from an aunt's cow). For the rest of his life Bewick, who was a hefty six-footer, was concerned with the proper

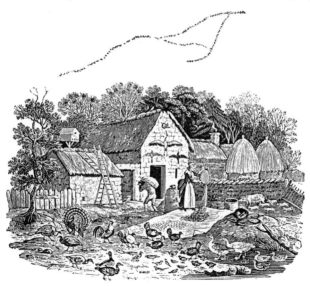

9 Landscape: Farmyard. *Vignettes* (No. 22). E.2291–1907

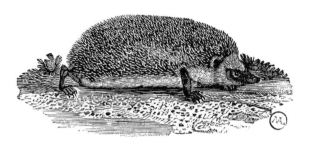

10 Hedgehog. *Quadrupeds* (No. 208). E.2261–1907

management of health for sedentary workers; stressing the need for artists and craftsmen to have 'little cots' with gardens to potter in, nearby towns to be visited for mental stimulation, and even 'dumbells to be exercised with half an hour before bed'. 'Were this more practiced,' he adds, 'we should have few dying of consumption.'

Among the mental stimulators of that time at Newcastle Bewick encountered Thomas Spence, whose views on common ownership once landed the latter in jail. Although himself an upholder of private property, Bewick undertook to cut the steel punches for the Spencean Reformed Alphabet. Another acquaintance was the encyclopedic George Grey, whose knowledge of chemistry and allied sciences caused him to be put in charge of a geological survey for Prince Poniatowski of Poland. An assignment for the mathematician, Dr Hutton, led indirectly to Bewick's being employed later on the publication of Isaac Newton's works. And there were other contacts of a less reputable kind which must have contributed to his skill as a naturalist and designer; these were the bird-catchers and dealers.

His apprenticeship over, Bewick returned to his parent's home at Cherryburn, a free man at last, in the winter of 1776. Here he worked on his own account till a sudden restlessness made him resolve to see more of the country;

and away he went to Scotland, with three guineas sewn into his waistband. Here we find him rehearsing the ferocious battles of the border ballads as he roams the hills, deciphering with the help of a passing traveller the Latin inscription on his idol Smollett's Memorial, visiting Loch Lomond and going into ecstasies about the Highland scenery: a true precursor of the Romantic Age. The return, by boat to South Shields, was less poetic. Most of the passengers were sea-sick, and Bewick found himself holding somebody's baby. Nothing daunted he set out again for Newcastle to earn his fare to London, where he arrived in October 1776 after three weeks on board a collier.

Here old schoolfellows met him with offers of lodgings and 'plenty of work', and took him on a tour of London's 'blackguard places'. Many were the evenings spent in moderate consumption of ale and lively argument at The George, Brook Street, and the Sunday mornings at St Andrew's Church, Holborn. Undeterred by childhood experiences Bewick now enjoyed a good sermon and was always going to hear 'preachers of various persuasions'. He was also a practising Christian, relieving hardship when he came upon it; which explains, as he tells us, why he never succeeded in putting by 'a surplus of cash'.

Stubbornly provincial in the London of Sheridan and Gainsborough, where men and women of fashion sat on

11 Impression of rain. *Vignettes* (No. 184). E.2372–1907

Chippendale chairs and tittered over Dr Johnson's grumpy aphorisms, Bewick stuck to his old cronies: the Gregson brothers, Philip of the Customs House, Christopher (now apothecary) Pollard, and William Gray. Like Cobbett, his close contemporary, like Millet, who detested Paris, he felt that life in the capital was not for him; a world of extremes, 'extreme grandeur and extreme wretchedness', he called it. Tyneside and its inhabitants seemed 'paradise' in comparison; and twenty-seven years later we find him still of the same mind. 'I would rather be herding sheep on Mickley Bank', he writes to his old and revered preceptor, Christopher Gregson, 'than remain in London, although by doing so I was to be made premier of England.'

The job which he in fact turned down was of a less exalted though more secure nature: a post at the Mint. Although he says he appreciated London's excellence in arts and sciences, and renewed valuable contacts such as with William Bulmer, the great English printer who later employed him on Thomson's *Seasons*, Bewick was in London for scarcely eight months. He did not get on with the cockneys of Clerkenwell. Only in his own native haunts did he feel himself able to be, as Carlyle puts it, 'a man

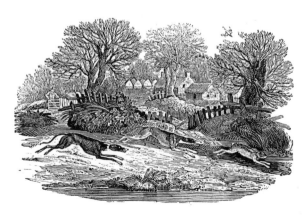

12 Hare Coursing. *Vignettes* (No. 248). E.2404–1907

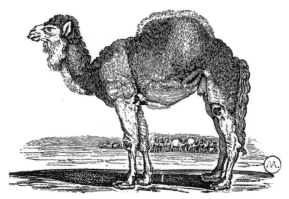

13 Dromedary. *Quadrupeds* (No. 61). E.2115–1907

very true of his own sort, a well-completed and a *very enviable* [man], living there in communion with the skies, woods and brooks, not here in ditto with the London fogs, the roaring witch-mongeries and railway yellings and howlings'.*

No doubt Newcastle, too, had its quota of grime and fog, but here Bewick contentedly set up his workshop. Wood was his preferred material, but he would engrave in copper or silver according to demand. With some reluctance he allowed himself to be persuaded into partnership with his old master; not without the notion, which never left him, that he would have been happier working uninterrupted and alone. Brother John joined him as an apprentice and sometimes one brother would do the drawing and the other would cut the block.

Although they quarrelled over John's fondness for bad company, the Bewicks were a close-knit family and the brothers remained in continued association. John based himself in London, teaching part-time at the Hornsey School of Art and commuting on horseback to his City office. But he was obliged to return to the country at intervals for the sake of his frail health.

* Not of course in Bewick's time.

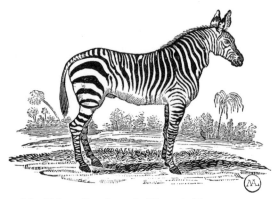

14 Zebra. *Quadrupeds* (No. 11). E.2065–1907

Christmas 1784 finds Thomas amusing himself sliding on the ice at Ovington, and suddenly a prey to dire forebodings. 'Gloomy days' were to follow. Parents and elder sister all died within a year, the mother from catching a 'perishment of cold' in a freezing bog while going to the aid of a sick neighbour; the other two from over-exertion and grief. 'After this', he writes, 'I left off my walks to Cherryburn the thought of which raked up sorrowful reflections.' However, the memories of country scenes observed during those 400-odd weekends, when he foot-slogged home, remained with him and went into the vignettes and miniature landscapes of the tail-pieces which are the chief delight of his work.

A man to honour his father and mother, Bewick had stayed single during their lifetimes in order to bestow on them his 'undivided attention', in consequence getting himself dubbed women-hater by the 'smirking lassies of Tyneside'. The hand of Miss Beilby had been denied him, but he had always admired a fresh face, and quite fell in love with the bare-legged lassies of the Highlands. Somewhat over-idealizing women, he had a 'tender regard for the whole sex'. London prostitution appalled him, but his hope was that rehabilitated girls could train as florists.

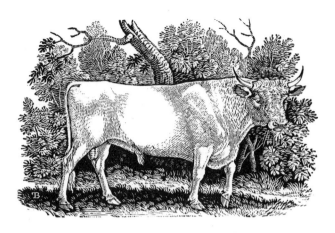

15 Wild Bull. *Quadrupeds* (No. 17). E.2071–1907

Once free of his obligation to his parents he married, not
the handsome young person with the nice nest-egg picked
out for him by his mother—she proved too unintelligent
for his liking—but a suitable helpmate, 'strong in adversity',
a Miss Isabella Elliot, who brought him a lifetime of
happiness. Three girls and a boy were born of this union,
and if they had the benefit in childhood of their father's
calls for greater freedom from the constraints of forced
education, then they were fortunate children. As soon as
he was old enough the boy, Robert, joined his father in the
family business.

Meanwhile Bewick's reputation was increasing. He was
the first artist to exploit fully the advantages of engraving
on wood cut across the grain. Traditionally, woodcuts were
printed from blocks of relatively soft wood, sawn from the
tree lengthwise like a plank. The design was drawn on the
wood and the areas to remain blank were cut away with a
knife, leaving the design in relief. The use of harder wood
(usually box) cut *across* the grain has the advantage that
it is less likely to splinter and can be cut cleanly with equal
pressure in all directions. It can be worked, like a copper

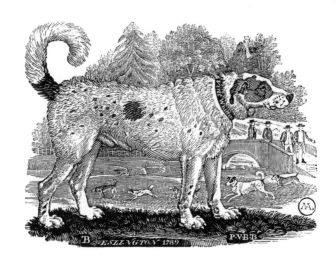

16 Newfoundland Dog. *Quadrupeds* (No. 137). E.2190–1907

plate, with a burin, which is capable of achieving more delicate effects than the woodcutter's knife. The fine lines cut with the burin are beneath the surface which carries the ink, and therefore print white. This led Bewick to conceive some of his designs in terms of white lines on a black ground and is the reason why the technique is sometimes known as the white-line method. A direct contrast to his early linear style is, for example, *Impression of Rain* (pl. 11), two carthorses standing with windmill in the background, where tonal masses give a three-dimensional effect.

Chapter **XXII** of the *Memoir* contains Bewick's own account of his progress. When he started, he says, it never entered his head that wood could compete with copper engraving. Indeed, eighteenth-century illustration and printmaking were mostly in the form of etching, the bitten plate being afterwards worked up to give the character of line drawings. It was not the engraver's task to be original, but simply to transfer the artist's picture on to the plate. Bewick was different. His themes were his own. And

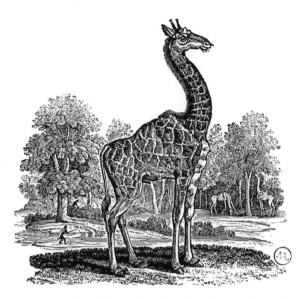

17 Cameleopard or Giraffe. *Quadrupeds* (No. 51). E.2105–1907

although, as Montague Weekley has suggested, there was
a lack of prudery which might have owed something to
Hogarth, Bewick's main 'stimulant' appears to have been
to hold the mirror up to nature.

Bewick would do his woodcuts as a kind of recreation
after the day's work. Their possibilities only began to
dawn on him as he saw the willingness of printers to put
the cuts to practical use. The first hurdle to be got over
was the 'pressmen's' apparent inability to produce a print
whose quality in any way corresponded to the 'labour
bestowed on cutting the designs'. Even if one of them, he
says, 'possessed any notions of excellence beyond the com-
mon run of workmen, his materials for working were so
defective that he could not execute even what he himself
wished to accomplish. The common pelt balls then in use
so daubed the cut and blurred and overlapped its edges
that the impression looked disgusting. To remedy this

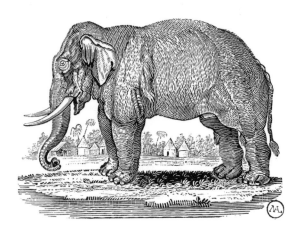

18 Elephant. *Quadrupeds* (No. 74). E.2127–1907

effect I was obliged carefully to shave down the edges round about.'

'The next difficulty', he goes on, '. . . took a long time to get over . . . and that was to lower down the surface on all the parts I wished to appear pale so as to give the appearance of the required distance; and this process will always continue to call forth and to exercise the judgement of every wood engraver, even after he knows what effect his *careful pressmen* [Bewick's italics] may be enabled to produce from this manner of cutting.'

The very fine lines were, of course, always liable to be damaged by the heavy pressure of repeated printings. Bewick managed to avoid this by his ingenious arrangement of the thicker lines and darker areas. These stouter surfaces acted as support and protection for the more delicate lines and greatly extended the working life of his blocks. Thus he was able to confirm to an interested inquirer that the newspaper 'fac' (i.e. a heavy initial with small vignette attached) including a view of Newcastle and the St Nicholas Church lantern spire, which he had cut

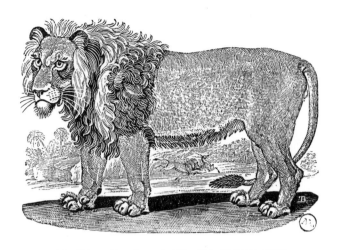

19 Lion. *Quadrupeds* (No. 75). E.2128–1907

for a local newspaper, had already served for over 900,000 printings and was still in use. Indeed with the right paper and printing, Bewick's surviving blocks still print today as well as ever.

Bewick, however, was no decrier of the work of other printmakers, past or present. He laments the disappearance of the large, cheap prints to be seen on the walls of every cottage and farm in his boyhood. These prints, produced, he supposes, from cuts made 'plankwise' from beechwood, usually commemorated the 'patriotic exertions' of the eminent, with some suitably edifying exhortation printed underneath. Contemporary colour prints, obtained by several printings, also come in for praise, particularly the examples sent him from Berlin by Cubitz.

Cross-hatching is another of Bewick's problems. He scratched his head over a profusely cross-hatched print by Dürer in the hands of the Rev. J. Brand, a Newcastle historian, and gives a touching account of how he experimented with two different printings to get the desired effect. However, the additional process seemed to him to be

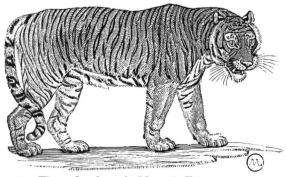

20 Tiger. *Quadrupeds* (No. 76). E.2129–1907

uneconomical; cross-hatching woodcuts for book-work is, he concludes, a waste of time. 'I could never discover', he says, 'any additional beauty of colour that crossed strokes gave to the impression beyond the effect produced by plain parallel lines.' He explains how variations in tone, and in colour even, can be achieved by thinning or thickening the dark strokes, and by placing them closer or farther apart. Both the *Hare Coursing* vignette (pl. 12) and the *Funeral at Cherryburn*, Bewick's last tail-piece, illustrate his astonishingly lively and subtle use of this technique— how the result can be either busy and vigorous, as in the former, where even the hurdles and hedgerows seem to be galloping with the hounds; or delicate and elegiac, as in the latter, where all nature sways in sympathy with the distant mourners. The wind ruffles the water, grasses bend, withies bow, and the long boat strains at its mooring as it waits for the coffin.

Producing such effects on so small a scale (the average size of a tail-piece was three inches by two—sometimes less) was exacting work. Fortunately his sight remained keen, and even in his seventies he could read the smallest newspaper print. But he speaks with feeling of 'severe confinement and application', and once after a bad illness in his sixtieth year he complains, 'the execution of the fine

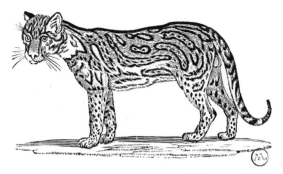

21 Ocelot. *Quadrupeds* (No. 83). E.2136–1907

work of the cuts was very trying to the eyes, and the compiling or writing the book [Bewick's publication of *Aesop's Fables*] by candle-light in my evenings at home, together injured the optic nerve, and that put all the rest of the nerves "out of tune", so that I was obliged for a short time to leave off such intense application until I somewhat recovered the proper tone of memory and sight.'

The *Fables* (1818) did not add greatly to Bewick's already established fame, however. This had come twenty-eight years earlier with his illustrations for *A General History of Quadrupeds* (1790), a book on which he collaborated with the man who had been his master and later became his partner. The *Quadrupeds* was Bewick's idea. Dissatisfied as a schoolboy with the animal pictures in children's books and convinced even at that age that he could do better, Bewick determined to have a go 'in the hope of administering to the pleasure and amusement of youth'. Mr Beilby's aims were more commercial. But having first satisfied himself on that score from his bookseller friends, and being of a bookish turn of mind, he agreed to write the text on the strict condition that *Quadrupeds* should be worked upon only out of office hours, so as not to impede the more pressing business of customers' orders.

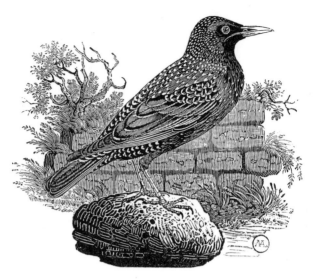

22 Starling. *British Land Birds* (No. 49). E.1799–1907

The first cut (of a dromedary, pl. 13) was begun on
15 November 1775, the day Bewick's father died; but the
book was not published till 1790. Bewick copied the more
exotic beasts from models he was able to locate in travelling
menageries and from 'Dr. Smellie's abridgement' of Buffon's
Natural History. Indigenous animals he sketched from life
or memory. His schedule was frequently upset by requests
from local landowners for prints of their champion livestock.
Sometimes these incursions were profitable, as in the case
of the *Chillingham Wild Bull*, when he not only got the
material for one of his finest cuts, but availed himself of
the presence of a splendid Newfoundland Dog, which sub-
sequently found its way into *Quadrupeds* (pl. 16). Some-
times they were not; as when he angered a sheep-breeder
by refusing to put into his drawing 'lumps of fat here and
there where I could not see it'.

To Bewick's surprise, so he says, the *Quadrupeds* sold
rapidly and went into several editions. The first edition

was a tall octavo volume, printed, as John Rayner tells us
in his introduction to the King Penguin on Bewick, 'with
the natural taste which provincial printers had not yet
lost'. Rayner refers here to the transition period, 'when
the technical advances introduced by Baskerville in Bir-
mingham were changing the appearance of books, and the
slightly rugged "antique" look, as it were, of eighteenth-
century books was giving way to a more modern clarity
of impression'. According to Rayner, the *Quadrupeds* was
by no means as well printed as were the London productions
of Bulmer (e.g. *The Seasons*) half a dozen years later; and
he adds, 'The small unevennesses of the paper sometimes
give a slightly rusty effect to those parts of the engravings
which should be black, and some of the contrasts of light
and shade are a little lost.' Nevertheless, the *Quadrupeds* is
a work of great charm, as is also *The History of British
Birds*, the first volume of which, *Land Birds*, appeared
seven years later in 1797.

The second volume, *Water Birds*, did not appear until
1804. Beilby had retired after the first volume, leaving
Bewick to tackle text as well as illustrations. Bewick was
obliged to buy him out, and groans a good deal about the
cash terms of the transaction, not to mention the encroach-
ment on his time. For he was now having to learn and to
pursue 'writing engraving', hitherto the province of his
partner. Still, he soldiers on, and designs for the Bank of

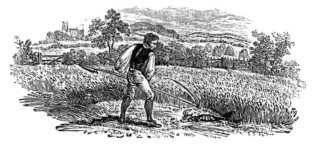

23 Worker in a hayfield. *Vignettes* (No. 118). E.2339–1907

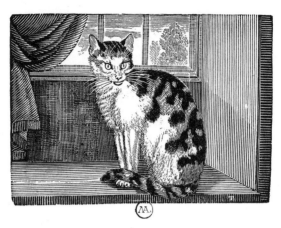

24 Domestic Cat. *Quadrupeds* (No. 87). E.2140–1907

Carlisle an unforgeable five-pound note, which is admired
by George the Third.

Delays and distractions notwithstanding, *British Birds*
is probably Bewick's finest achievement. Like *Quadrupeds*
it went into several editions, the sixth and last to be
published in his lifetime, in 1826. As in the tail-pieces, the
authentic 'feel' of the *Birds* is unmistakable; Bewick so
often conveys what John Rayner has described as the
character of a bird, 'the clownish self-confidence of the
starling . . . and the apprehension of the quail'.

While consulting all known authorities from Pennant
and Gilbert White to his contemporary Col. George Mon-
tague's *Ornithological Dictionary*, Bewick had resolved to
'copy nothing from the work of others'. An already con-
firmed bird-watcher in his childhood—when the common
varieties had become, as he puts it, his 'intimate acquain-
tances' and the 'rare visitants' such as snipe and redwing
'a source of extreme pleasure and curiosity'—he had a
head start. The stuffed bird was at that time, of course, no
uncommon ornament, and we find Bewick spending two
months in the summer of 1791 in a private museum on the

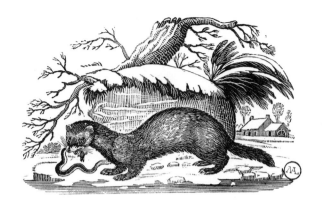

25　Polecat. *Quadrupeds* (No. 93). E.2146–1907

Wycliffe estate, drawing from the collection of the previous owner. But no sooner back in Newcastle than he feels dissatisfied with 'the very great difference between preserved specimens and those from Nature; no regard having been paid, at that time, to fix the former in their proper attitudes, nor place the different series of feathers so as to fall properly on each other. It has always given me a great deal of trouble', he continues, 'to get at the markings of the dishevelled plumage; and when done with every pains, I never felt satisfied with them.'

Despite his declared objection to bird slaughter, he is driven to wait for 'birds newly shot or brought to me alive'. In this the officers of the 4th Dragoons oblige him to a man. Indeed, birds are sent to him from 'various parts of the kingdom' by keen amateurs, natural history and bird-spotting being then very much in vogue. Local Learned Societies consisting of philosophers, mathematicians, and scientists proliferated in Britain during the second half of the eighteenth century; the most famous was the Lunar Society of Birmingham.

The results of his labours were universally acclaimed. Paying a second visit to Edinburgh late in life, he is wel-

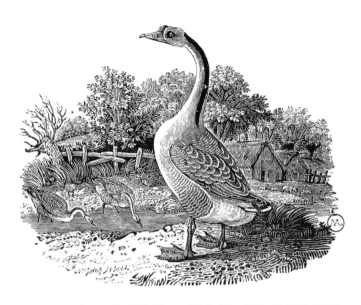

26 Swan Goose. *British Water Birds* (No. 100). E.2008–1907

comed by scholars and artists. He is shown the eidograph (an invention for enlarging and reducing the size of drawings), and he tries his hand at lithography. Some years after his death the Linnaean Society paid him the tribute of giving his name to the Bewick swan, and in 1844 William Howitt wrote in his *Rural Life in England* that for country lovers 'the opening of Bewick was a new era in their lives'. Writing on a rather more lofty note shortly after the first publication of the *Memoir* in 1862, John Ruskin refers to Bewick's 'unerring hand' and his 'inevitable eye', declaring the execution of the plumage to be 'the most masterly thing ever done in woodcutting'; and pronouncing him a 'Veronese' among wood-engravers.

By this time Bewick's best-known works were no longer being reprinted as popular introductions to Natural History. The Rev. F. O. Morris, member of the Ashmolean Society, had arrived on the scene with his *History of British*

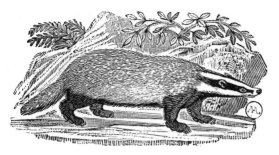

27 Badger. *Quadrupeds* (No. 106). E.2159–1907

Birds, published in 1870 in full colour. However, Bewick continued to be sought by collectors. In 1924 the late Sir Francis Meynell had the idea of using Bewick's designs in his *Week-end Book*, for the section on Bird Recognition.

Since the Second World War, interest in Bewick's art has grown. This may be attributable to the frequent, but sometimes unacknowledged use of his designs as printers' ornaments.* Other factors may be today's increased preoccupation with graphics, and the current nostalgia for what is taken to be the simple rural life.

But if Carlyle chose to imagine Bewick wandering carefree among 'ye banks and braes' (and indeed who better than Bewick to have illustrated the rugged Burns?), then Carlyle is ignoring the daily grind at the workshop by St Nicholas' Churchyard, where the American naturalist Audubon found Bewick in his seventy-fifth year still 'full of life, active and prompt in his labours', in spite of gouty fingers.

As well as the poems of Burns, those of another Scot were printed in 1805 with accompanying vignettes by Bewick after John Thurston: these were *The Seasons* by James Thomson—an astute combination here by the London printer William Bulmer. Never can author and

* e.g. in the Faber paperback of *The Leaping Hare*, by George Ewert Evans and David Thomson, 1974, where the Bewick hare is used on the title-page.

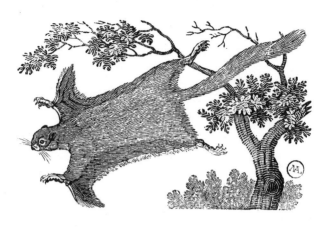

28 Flying Squirrel. *Quadrupeds* (No. 157). E.2210–1907

illustrator have been so much in tune. 'Welcome kindred
glooms! Congenial horrors, hail!', cries Thomson in the
opening stanza of *Winter*. Bewick answers from the night-
dark wood midst whirlwinds of snow, and tempests howling
overhead, that he too has known sublimity and been a
prey to notions of omnipotence. He adds, by way of explana-
tion for such extravagances, that 'without being supported
[on his long walks to Cherryburn] by ecstasies of this kind,
the spirits, beset as they were, would have flagged and
I should have sunk down'. Thus does Bewick acknowledge
the power of poetry, allowing it greater licence with nature
than can be permitted to the graphic arts, but holding
stoutly to the view that such vicarious experience is no
substitute for the real thing.

Like many of his generation Bewick was much possessed
by death, dwelling on last visits to the bedside and soli-
loquizing in churchyards to the accompaniment of poems,
Bible references, and high-minded musings about the
destiny of man. And no wonder; Bewick's lifespan was a
time of enormous social upheaval and costly war. At home
the innumerable Enclosure Acts, designed to improve agri-

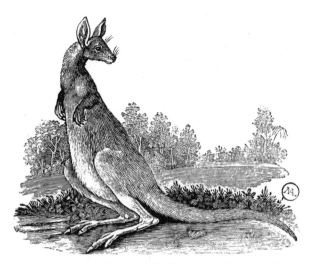

29 Kangaroo. *Quadrupeds* (No. 188). E.2241–1907

cultural production, bore hard on the peasant popula-
tion. The advance of steam, which was making possible
the industrialization of the North Midlands, had created
a new class of urban poor and a great division between
employer and employed. There was slavery in the New
World and much starvation in the Old. The Seven Years
War had overshadowed Bewick's childhood. Scarcely was
British rule established in the Colonies before the American
War of Independence broke out. That ended in 1783. The
French Revolution followed and pretty well every European
government felt itself threatened. By 1793 Britain was
involved in hostile action against the French, which con-
tinued almost unbroken, except for the Peace of Amiens
in 1802, until Napoleon's defeat at Waterloo in 1815.
During that time also secret societies in Ireland plotted
rebellion. Bloodshed and the passing of the Act of Union
(1800) were the result. Moreover, in the two years prior to
Waterloo the Navy was fighting out a further and final
instalment of a new American war.

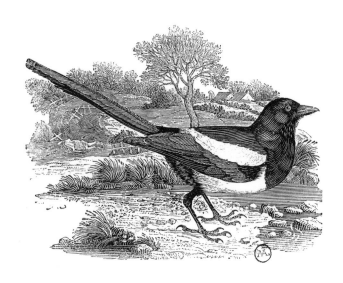

30 Magpie. *British Land Birds* (No. 43). E.1793–1907

These were years of harsh criminal laws, repressive measures, 'press gangs', sporadic mutinies, and ruinous taxation. Up and down the country we find clubs being formed where working men and members of the educated classes met and made known their demands for reform. Bewick was among them. Indeed, he asks himself in the *Memoir* whether he has not spent too much time in these 'debatings'.

A moderate man, who came to detest all wars, Bewick is, nevertheless, full of contradictions. He wanted a fair chance for every man, but had no use for Major Cartwright's scheme for universal suffrage, since this would mean giving votes to 'the ignorant and wicked'. He was against cruelty to animals, and an advocate of prison aftercare. He was in favour of Catholic Emancipation: yet his views on the desirability of social pruning would brand him a reactionary. He was, as might be expected, a great conservationist; he deplored the pollution of rivers by town and

industrial effluent, but equally the exclusion of working men from streams which might have provided much-needed food.

Sadly, there is no coming together in him of the reformer and the artist. There are no cuts showing one half of the world how the other half lives; no miners on all fours in pits awash with water, no women and children shown working underground. Had they been ordered by customers doubtless he would have done them. But these are not subjects for delight, and the vignettes he did for his own pleasure.

In any case Bewick saw himself primarily as a craftsman, not an artist. For him, as for Blake, his contemporary, the artist was a kind of visionary 'with talents to excite wonder and improve society'. Visual excitement and social commitment have since tended to part company. (What, one wonders, would Bewick have thought of some of today's ideological art?)

Yet Bewick did long for society to improve, for tolerance to reign, and for bigoted teachings which 'so disfigure the comely face of religion' to disappear. With what Reynolds Stone has described as remarkable prescience, Bewick in the last year of his life is already looking to America as the future regenerator of the Old World. In 1828 could anything have been more prophetic?

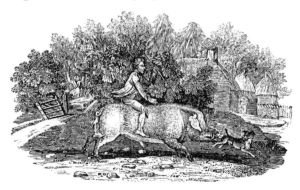

31 Pig. *Vignettes* (No. 10). E. 2285–1907

BIBLIOGRAPHY

Thomas Bewick, *Memoir of Thomas Bewick*, ed. Ian Bain, London, 1975

Julia Boyd, *Bewick Gleanings*, Newcastle-upon-Tyne, 1886

Austin Dobson, *Thomas Bewick and his Pupils*, London, 1884

John Jackson, *A Treatise on Wood Engraving*, London, 1839

John Rayner, *A Selection of Engravings on Wood by Thomas Bewick*, London, 1947

Robert Robinson, *Thomas Bewick, his Life and Times*, Newcastle-upon-Tyne, 1887

David Croal Thomson, *Thomas Bewick*, London, 1882

Montague Weekley, *Thomas Bewick*, London, 1953

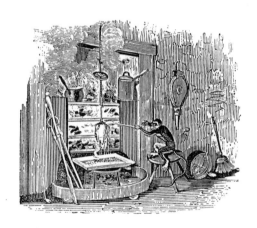

32 Monkey at spit. *Vignettes* (No. 210). E.2385–1907